The Face of Pancho Villa

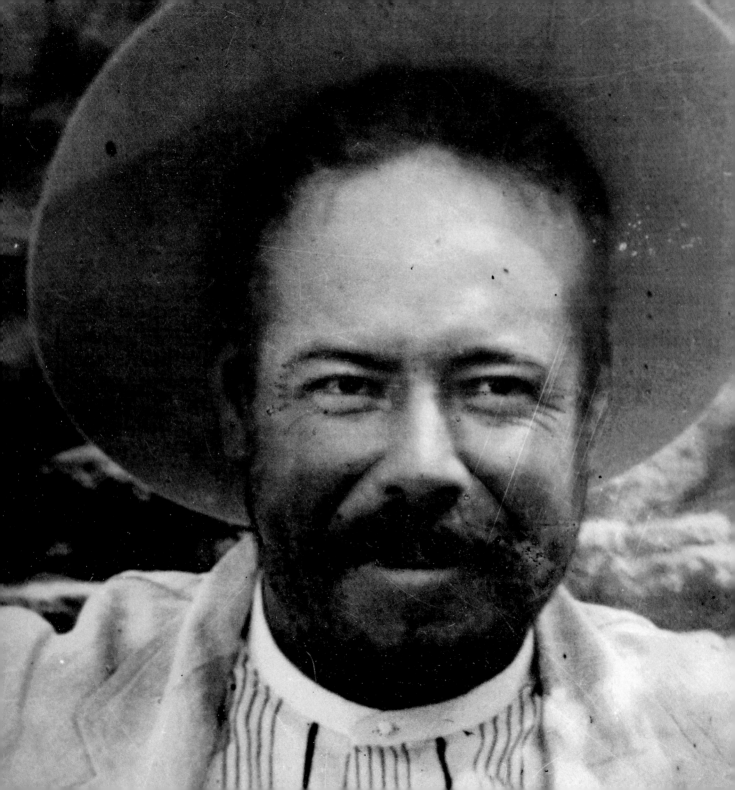

THE FACE OF PANCHO VILLA

A HISTORY IN PHOTOGRAPHS AND WORDS

Friedrich Katz

Cinco Puntos Press El Paso

Originally published in Mexico as *Imágenes de Pancho Villa*, a coedition of Ediciones ERA and Instituto Nacional de Antropología e Historia, copyright © 1999.

FIRST EDITION
10 9 8 7 6 5 4 3 2 1

Katz, Friedrich.
 [Imagenes de Pancho Villa. English]
 The face of Pancho Villa / by Friedrich Katz. -- 1st ed.
 p. cm.
 ISBN 1-933693-08-8
 1. Villa, Pancho, 1878-1923--Pictorial works. 2.
Revolutionaries--Mexico--Pictorial works. I. Title.

 F1234.V63K3613 2007
 972.08'16092--dc22

 2007000965

Thanks to Luis Humberto Crosthwaite for his editorial help.

Book and cover design by JB Bryan.

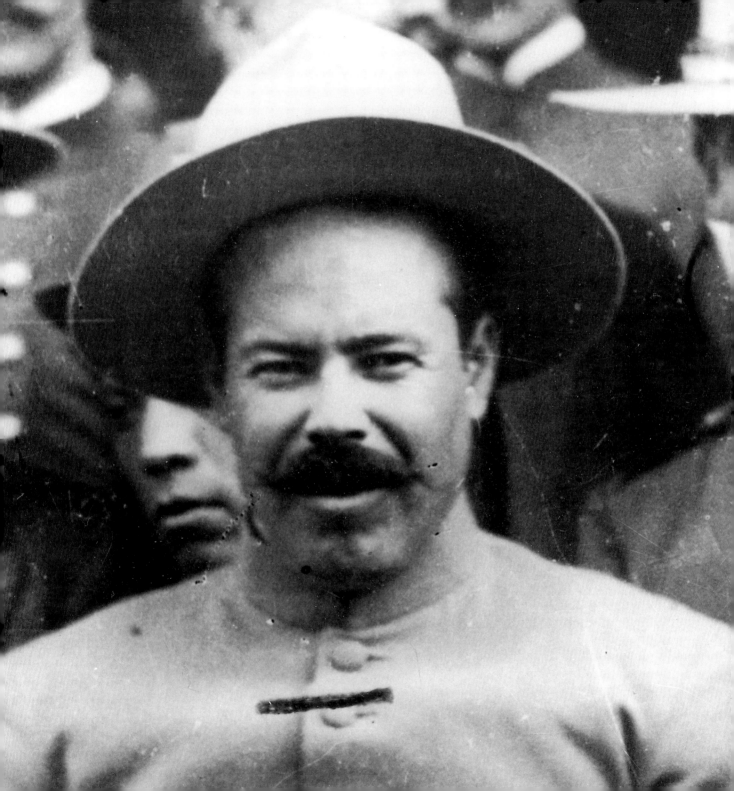

Francisco (Pancho) Villa

Friedrich Katz

Francisco (Pancho) Villa—together with Benito Juárez and Emiliano Zapata—is probably the best known personality from Mexico's history. Like his ally Zapata, Villa is also very different from all the other major leaders of twentieth-century revolutions. Lenin, Mao Tse-tung, Ho Chi Minh and Fidel Castro were all highly educated intellectuals who led well-organized political movements. Villa, by contrast, scarcely had any education and he came from the lowest rungs of society—he had been a sharecropper on a large hacienda in the state of Durango. He never led a political party or political organization, yet he managed to play an enormous role in the Mexican Revolution, one of the great social upheavals of the twentieth century.

Villa was without any doubt the most controversial leader that the Mexican Revolution produced. Nothing is more characteristic of the contradictory emotions that he produced than the comments of Mexican newspapers after his assassination. *Omega* called him "a gorilla and a troglodyte." The newspaper continued: "He was a wretch, whose generation is one more blot for the revolutionary leadership."[1]

This is in stark contrast to the vision of Villa offered by *El Demócrata*. "To the humble who have groaned under the slave driver's lash, Villa was the avenger; to those who were despoiled by the master, Villa was justice; to those whose blood still boiled from the outrage of '47, Villa was the soul of Mexico confronting Pershing; to the speculators in land and blood, Villa was a bandit and a monster."[2] While *Omega*'s editorial doubtless reflected the views of Mexico's upper classes and part of its middle sectors, the perspective of *El Demócrata* is that of Mexico's lower classes, who strongly identified with Villa and whose opinions were reflected in countless corridos:

[1] *Omega*, Mexico, July 2, 1923
[2] *El Demócratica*, Mexico, July 21, 1923

Despedida no les doy
la angustia es muy sencilla:
la falta que hace a mi patria
el señor Francisco Villa.

Políticos traidores de instintos tan venales
que a Villa le temían por su gran corazón
y crearon en conjuntos sus planes criminales
que sirven de vergüenza a toda la nación.

I do not bid you farewell.
Anguish is very simple.
What a loss to my country,
Señor Francisco Villa.

Corrupt and traitorous politicians
who feared Villa's noble heart,
they conceived criminal plans
that shame the whole nation.[3]

These extremely contradictory comments were the result of Villa's extraordinary career as one of the main leaders of Mexico's revolution.

When Villa was born Doroteo Arango on the Rancho de la Coyotada in Mexico's northern state of Durango in 1878, no one would have remotely suspected that anything beyond the life of a hacienda sharecropper lay in front of him. His parents were sharecroppers, working for one of northern Mexico's richest hacienda owners, Agustin López Negrete.

[3] Vincente T. Mendoza, *El corrido mexicano*, Fondo de Cultura Económica, Mexico, 1976, pp. 67-69.

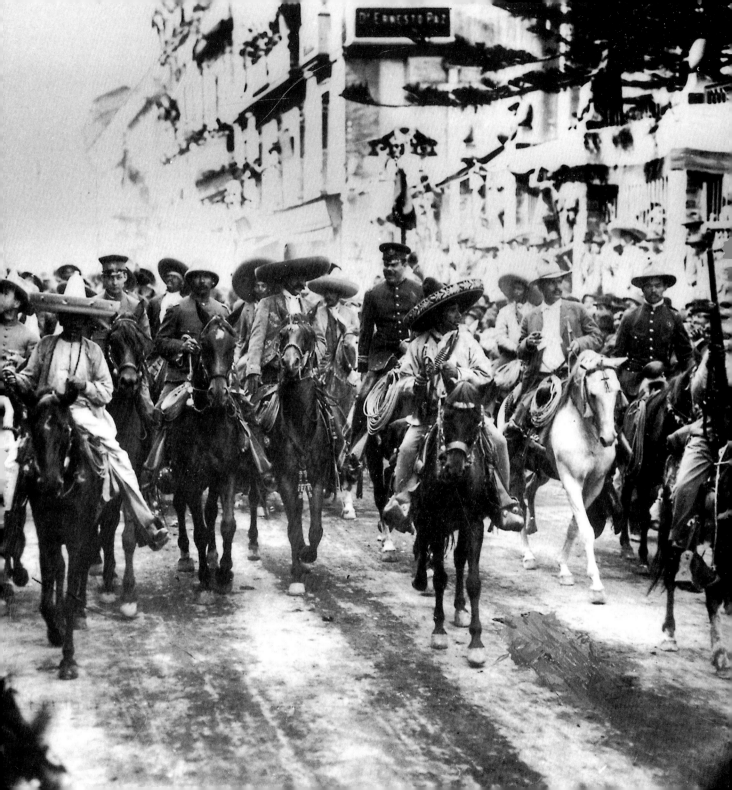

His father died when Doroteo was still very young. Doroteo helped his mother support the family, but became an outlaw in his early teens. Why he did this is still the subject of legend and controversies. Villa himself states in his memoirs that one day he came home and found Don Agustin López Negrete—"the master, the owner of the lives and honor of us, the poor people"—standing in front of his mother. She was telling Negrete, "Go away from my house—why do you want to take away my daughter?" Young Villa became so furious when he witnessed this scene that he took a rifle from his cousin and shot the hacendado in the foot.[4] He then fled into the mountains, relentlessly pursued by Mexico's police—los rurales. Although they managed to trap him, Villa killed several of them and was able to flee.

While peon women were in fact at times raped by hacienda owners or foreman, there is no evidence that this happened in the case of Villa's sister. When he was arrested several years later, he was never charged with wounding a hacendado or killing rurales but rather with the minor crime of stealing two guns.[5]

Throughout history, outlaws have often tried to show that one of the reasons they violated the law was that they were forced to do so because they were victims of injustice. Even if the story of the rape of Villa's sister is not true—and there is no evidence for it one way or the other—the Porfirian regime in Durango was such that many innocent people were forced to lead the lives of outlaws.

Under the dictatorship of Porfirio Díaz, there was very little justice for the poor classes of society. Describing conditions in the state of Durango at the end of the Díaz dictatorship, the British vice consul in the city of Durango wrote, "The governor has been appointed from Mexico: he in turn has appointed as jefes—politicos—men who, to say the least, could never be elected. Such men, badly underpaid and with absolute power, have established a traditional 'caciquismo.' The administration of justice has been very unsatisfactory and dilatory and the incidence of state taxation most unequal, falling heavily on the miners and small merchants and lightly on the great estates and haciendas." [6]

[4] Martín Luis Guzmán Archives, Manuel Bauche Alcalde, "El general Francisco Villa," pp. 6-7.
[5] Durango Archives, Díaz Couder to the governor, March 24, 1902.
[6] Public Record Office, Foreign Office Papers, London, 371-1147-17946, Vice Consul Graham to Hohler, April 19, 1911.

If a member of the state's upper classes had a falling out with any of his peons or members of the lower classes, the latter became subject to the leva, the forced recruitment into the army. "In reality, the lottery [military draft] is a mere pretext to allow men of influence to get rid of persons they don't like and against whom they are carrying out reprisals," Durango lawyer Pedro Marín wrote to Porfirio Díaz in 1907.[7] Faced with the bleak choice between life as an underpaid soldier living in conditions of squalor and semi-slavery and the life of an outlaw, it is not surprising that many men went into the mountains and attempted to lead an independent life.

In 1899, Arango was caught by the authorities. Since they obviously felt that his crimes were not too serious, they sent him to serve as a soldier in the army. He deserted one year later. Feeling certain that he might be shot as a deserter, he left his native state of Durango for the neighboring state of Chihuahua and changed his name to Francisco Villa.

In Chihuahua, he led a life of contradictions. On the one hand, he made an honest living as a muleteer and as an employee of foreign corporations. They recognized his talents as a leader of men and frequently employed him to transport goods or even money that he seems never to have stolen.

On the other hand, he was also a cattle rustler. But in the eyes of many Chihuahuans, this was not a serious crime. On the contrary, many believed that rustlers who took cattle from large estates were simply restating a traditional right. Before these estates had acquired huge amounts of government lands during the Díaz dictatorship, the cattle on those lands had been wild and had been the property of anyone who captured them. It's not surprising then that many men who rose up against the Díaz dictatorship in 1910 and joined Francisco Madero—who had challenged Díaz' authoritarian rule in Mexico and called for the people to revolt in favor of a democratic regime—did not consider Villa a criminal.

In his Plan of San Luis Potosi, Madero called for the return of expropriated lands to their former owners. This demand had a tremendous response in Chihuahua—in large parts of the state a special kind of independent countrymen had developed. These were rancheros whose ancestors

[7] Durango Archives, Marín to the governor, February 18, 1907.

had received land from the Spanish Crown at the end of the 18th century in order to fight off the Apaches. For one century they had fought against Indian raiders from the north. After 1884—when the Apaches were finally defeated, when railways linked Chihuahua to the rest of Mexico and the United States and land values rose enormously—many of these men lost their lands to large land owners. They became deeply resentful of the Díaz regime.

They especially resented the state's largest and wealthiest family clan, that of Luis Terrazas and his son-in-law Enrique Creel. Juan Hernández—Porfirio Díaz' commander in Chihuahua—expressed this clearly by saying that he felt that the main reason the people of Chihuahua revolted was their hatred of "General Don Luis Terrazas, the richest man in Chihuahua who controls all large and small enterprises, including the public urinals." This hatred was combined with "ancient conflicts over the distribution of communal lands, frequent disappearances of unmarked cattle, excessive pressure by prefects and mayors with a low degree of education, increase in taxes which small businessmen have to pay above all and increases in the individual taxes."[8]

Francisco Madero called the people of Mexico to revolt against Porfirio Díaz' dictatorship on November 20, 1910. While sporadic fighting broke out on that day in many parts of Mexico, there was only one genuine insurrection and that took place in Chihuahua. For two months, the Chihuahuan revolutionaries stood practically alone against the might of Díaz' well-trained federal army, yet they were not defeated. The exceptional fighting tradition of Chihuahua's villagers—who for more than a century had fought against Apache raiders—was a major factor in explaining their unique role in this first phase of the Mexican Revolution. It could also be attributed to the wealth of Chihuahua's haciendas, which allowed the revolutionaries to supply themselves with horses and food and money, and to the promixity of the American border where they could buy unlimited amounts of arms.

Last, but by no means least, were the fighting capacities of the two main military leaders of the revolution, Pascual Orozco and Francisco Villa. Orozco, a muleteer, came from a well-known and

[8] Porfirio Díaz Archives, Universidad Iberoamericana, 017356-017365, anonymous, unsigned report passed by Juan Hernández to Porfirio Díaz.

established family in the mountain area of the Guerrero district in Chihuahua. He was well known in his area and had a large number of relatives. Thanks to his activities as a muleteer, he knew every nook and cranny of the mountain region of Chihuahua. He was an educated man and a born leader. Hundreds of Chihuahuans rallied to him.

The second leader of the Revolution, Pancho Villa, didn't enjoy any of Orozco's advantages. He had practically no family in Chihuahua, had no education, and had far less of a popular following. In fact, he brought only twenty-eight men to La Cueva Pinta, the meeting place of a group of armed revolutionaries led by the head of the boilermakers' union and political leader of Madero's party in the city of Chihuahua, Cástulo Herrera.

It's not difficult to understand why Villa joined the Revolution. His persecution by the authorities from Durango, his forced enlistment into the army, and finally his vain attempt to set up a butcher shop in the state of Chihuahua—where the monopoly for the sale of meat was held by the Terrazas-Creel clan—were all factors that brought him into the Revolution. What convinced him of the righteousness of Madero's cause was a long talk with the political leader of the Revolution in Chihuahua, Abraham Gonzalez, a man who was as courageous as he was honest. Villa soon turned out to be a far more capable leader then Herrera who was nominally in command of the forces which Villa had to join. Villa soon became its main military leader.

He inflicted one of their first defeats on the federal army and his audacity became legendary. With forty men, he attacked a far larger federal force. When the soldiers pursued him, he put sombreros on many of the hills surrounding the battlefield so that federal soldiers believed they faced a much larger force than the one Villa had brought to the battle.

What further enhanced Villa's standing among the revolutionary army was that he maintained an iron discipline. In spite of his reputation as an outlaw, he prevented any kind of looting or pillage. The speed with which Villa managed to capture the hearts and minds of the revolutionary army was described by Ignacio Herrerias. Herrerias was definitely not a revolutionary since he was a correspondent for *El Tiempo*, a newspaper published in Mexico City at a time when the Díaz regime was

firmly in control of the capital. "This Francisco Villa," Herrerias wrote, "is the man most respected among the revolutionaries. While they love and obey Orozco blindly, they fear Villa more since they know that he will have no inhibition if he wishes to impose his authority. It is said that he committed many offenses before he took part in the revolution, but it is stated that since he joined he has become one of the most honest and incorruptible leaders, who prevents his men from committing offenses." [9]

Villa felt a deep, but not blind, loyalty to Madero. When Madero decided to withdraw his troops from the siege of Ciudad Juárez—out of fear that bullets could deflect to the neighboring city of El Paso and provoke an American intervention—Villa prevented this plan from being carried out. He feared that the retreat of the revolutionary army would be demoralizing to the troops. Against Madero's orders, and together with Pascual Orozco, Villa attacked and took Ciudad Juárez. The result was the agreement between the revolutionaries and the Mexican government that led to the resignation of Díaz and the carrying out of free elections in which Madero was finally elected president of Mexico.

Villa's loyalty to Madero was not always reciprocated. When Pascual Orozco—Villa's former jefe—rebelled against Madero, Villa remained loyal to the Mexican president. At Madero's suggestion, Villa joined his own guerrilla troops with the federal army which had been sent to fight against Orozco—it was led by General Victoriano Huerta. Huerta, who hated all revolutionaries and wanted to destroy their remaining military contingents, imprisoned Villa under the pretext that the latter had wanted to rebel against him. He was only prevented from executing Villa by one of his own officers who objected to such an execution and by the intervention of Madero. Villa was brought to Mexico City where he was imprisoned first in the penitentiary and later in a military prison. Although no charges could be proven against him, the military refused to release Villa and Madero did not intervene in his favor. With great difficulty, Villa managed to escape from prison and make his way to El Paso. In spite of Madero's negative attitude, Villa reiterated his loyalty to the Mexican president from exile.

[9] *El Tiempo*, Mexico, April 1911.

VILLA EN LA SILLA PRESIDENCIAL CASASOLA=FOT. No 6.

In March 1913, after the murder of Madero in a coup organized by Huerta, Villa crossed the border into Chihuahua with eight companions. By the end of 1913, Villa had assembled a force of more than 3,000 men. He could now give full rein to his tremendous military capacities. In August 1913, he was able to organize and discipline a large array of guerrilla fighters. In spite of the fact that he didn't have any artillery, he was able to capture the important railway center of Torreón.

In November 1913, he scored an even more important victory. He captured a coal train that was en route to the border of Ciudad Juárez. He loaded his troops on the train and had his own wire operator telegraph headquarters in Ciudad Juárez that the train would be attacked if it approached Chihuahua. His instructions from the unsuspecting federal command were to return immediately to Ciudad Juárez and send news of their progress from each train station, which they did with the supervision of Villa's telegraph operator. In the early hours of the morning, the train steamed into the city of Ciudad Juárez. The federal soldiers were taken completely by surprise and Villa, after a brief combat, was able to capture the city.

At this point, General Mercado, who was in charge of federal troops in the capital city of Chihuahua, saw that he was cut off from supplies both from the south and the north. With his troops and part of the state's oligarchy—including the patriarch Luis Terrazas—he evacuated the capital city to the Mexican border city of Ojinaga.

On December 1, Villa and his troops entered Chihuahua to the cheers of thousands of the inhabitants of the state capital. A few weeks later his military commanders elected Villa provisional governor of Chihuahua.

When Villa assumed the governorship of Chihuahua he was thirty-five years old and in the prime of his life. An American doctor who knew him well wrote that, "He weighs about 175 pounds, he is well developed in a muscular way; has a very heavy protruding lower jaw and badly stained teeth… He has the most remarkable pair of prominent brown eyes I have ever seen. They seem to look through you; he talks with them and all of his expressions are heralded and dominated by them first; and when in anger or trying to impress a particular point, they seem to burn, and spit out sparks and flashes between the hard drawn, narrowed and nearly closed lids. He is a remarkable

horseman, sits on his horse with cowboy ease and grace, rides straight and stiff-legged Mexican style, and would only use a Mexican saddle. He loves his horse, is very considerate of [its] comfort probably due to the fact that they have aided him in escaping from tight places so many times. He has often ridden over 100 miles within twenty-four hours over the roughest mountain trails … He dresses very commonly…he is never so happy as when he is performing some rough riding stunts or attending a cock fight, one of his pet diversions."[10]

Villa had the reputation of being one of Mexico's greatest gunfighters, "For Villa," one of his subordinates reported, "the gun was more important than eating and sleeping. It was a part of his person indispensable to him wherever he was, even at social occasions, and one can say that it was only very rarely that he did not have the gun ready to be drawn or placed in his gun belt."[11]

These qualities certainly helped Villa to establish a unique relationship with the men under his command. Nevertheless, they were not the only reasons for that relationship. "He has further endeared himself to the lower classes," another observer reported, "and to his followers by his manifest lack of fear, his simple dress, simple habits, and rough unadorned speech set off by very forceful profanity and quaint obscenities. In all press interviews at public gatherings, he always makes it a point to lay stress on the fact that he is a simple uneducated, unlettered man who has never had any advantages of culture. If he had a Machiavelli for an adviser, he could not have found a surer way to the hearts of his followers."[12]

Villa attempted to establish personal links to his soldiers. He had a prodigious memory and was able to identify many of them by name. He frequently sat down at their camp fires and shared their meals. When a soldier had personal problems or needed money for his family, Villa could be very generous.

But Villa could also be extremely cruel. In a fit of anger he was capable of killing, often regretting his actions later. While he loved the good life, acquiring money was not one of Villa's important

[10] National Archives, Military Intelligence Department, 5761-1091-3, Carlos E. Husk to Hugh L. Scott, June 5, 1914.

[11] Silvestre Terrazas, *El verdadero Pancho Villa*, Ediciones ERA, 1985, p. 127.

[12] National Archives, Military Intelligence Department, 5761-1091-31, box 2348, Edwin Emerson to Leonard Wood, May 14, 1914.

aims. He didn't smoke, he didn't drink—when he occupied a city all saloons were closed—but his love of women was all embracing. He married at least four women without divorcing his previous wives. The number of girlfriends he had—he bore children with many of them—was far larger. He was a good father, attempting to provide for and support his children.

While most contemporary observers were impressed by the discipline Villa kept among his troops, they were repelled by the fact that after each battle he ordered captured officers as well as Orozquista volunteers to be shot. Only plain soldiers were spared and given the opportunity to join Villa's army. In this respect, Villa was only following the orders of the supreme leader of the Revolution, the governor of Coahuila, Venustiano Carranza. Carranza had revived Benito Juárez' law of January 25, 1862, which considered all those who were fighting against the legitimate Mexican government as subject to execution.

In a letter to the governor of Arizona, W. B. Hunt, Carranza wrote, "It is true that the established principles observed in international war grant prisoners the privilege of pardon or immunity from bodily harm, but in civil struggles the most civilized nations at all ages have employed more rigorous and bloody means even than the ones we have been compelled to adopt. And with reference to the executions of the officers in the city of Juárez, these should be perceived not as any needless cruelty inflicted upon prisoners of war, but merely such punishment as was described by the law applicable to offenders against the public peace and safety."[13]

As Woodrow Wilson's special representative in Mexico, John Lind asserted, "Reporting on Villa's execution of prisoners: his acts in this regard should be judged by Mexican standards. In so far as he allowed any captives to escape death, to that extent he is more humane than the commanders of the federal forces. They murder all captives."[14]

In spite of the fact that he possessed little education, Villa was not a man without ideology and that ideology was by no means limited to hatred of the oligarchy. Perhaps his very lack of education made him into a quasi-fanatical adherent of the importance of education. During the time he controlled Chihuahua, a large number of new schools would be created and street children would be

[13] *New York Times*, December 10, 1913; Periódico Oficial del Estado de Chihuahua, January 14, 1914.
[14] The Papers of Woodrow Wilson, 29:15, John Lind to William Jennings Bryan, December 5, 1913.

sent into boarding schools to be educated. While Villa was far from being a socialist, he did believe in some kind of transfer of goods from the rich to the poor and in land reform. His ideas of land reform, though, reflected conditions in Chihuahua where the rancheros had been organized since colonial days into military colonies.

●

"When the new republic is established," Villa told U.S. correspondent John Reed, "there will never be any more army in Mexico. Armies are the greatest support of tyranny. There can be no dictator without an army. We will put the army to work. In all parts of the republic we will establish military colonies composed of the veterans of the Revolution. The state will give them grants of agricultural lands and establish big industrial enterprises to give them work. Three days a week they will work and work hard because honest work is more important than fighting and only honest work makes good citizens. The other three days they will receive military instructions and go out and teach all the people how to fight."[15]

He was not religious and had strong misgivings about priests. "A priest is God?" he rhetorically asked in an interview with an American reporter. "They are not; they may teach the doctrines of Christ, but that does not mean that because they teach what is good they should themselves be permitted to break nearly all of the commandments as my experience teaches me they always do."[16]

Nevertheless Villa respected the profound attachment to the Catholic Church of most of his men and never took drastic anticlerical steps such as most leaders of the Revolution who supported Venustiano Carranza did. He never closed churches and did not prohibit religious schools.

Villa combined xenophobia with selective nationalism. For reasons he never made clear, he profoundly hated and despised the Chinese though he had great respect for the Japanese. He hated Spaniards whom he blamed for the ills of Mexico, but he seems to have admired the United States for a long time, and only became anti-American when the Wilson Administration, in a later stage of the Revolution, turned against him.

[15] John Reed, *Insurgent Mexico*, Simon & Schuster, New York, 1969, pp. 133-34.
[16] *New York American*, July 19, 1914, John Roberts interview with Villa.

Villa had little faith in a strong central state. He believed that most individual states should retain a large measure of autonomy and that the central government should be weak and exercise little control over most of the country.

The Villista leadership was of an extremely heterogeneous nature. Some Villista generals such as Toribio Ortega and Calixto Contreras were village leaders who, for many years during the Porfirian dictatorship, sought to prevent their community's lands from being expropriated by wealthy landowners. According to a military commander who fought against him in 1914-15, Orestes Pereyra, a tinsmith from the Laguna area, "was a man who looked like the heroes of the war against the United States with his long hair falling to one side over his mutilated ear…he was a man always correctly dressed and equally correct in his actions; always fair in his appraisals, humble and conscious."[17]

Some of Villa's military leaders had been close to the assassinated Mexican president. This was certainly the case of Raul Madero, the president's younger brother, who became an officer in Villa's army. It was true as well of his commander Eugenio Aguirre Benavides, a man related to the Maderos by family ties, and of Jose Isabel Robles, a former teacher on one of Madero's haciendas. Manuel Chao was a former school teacher, while Maclovio Herrera was a ranchero from the Parral area. All of these men commanded a large amount of prestige and respect both among their soldiers and among the civilian population. The same cannot be said of Tomás Urbina, the former crony of Villa's from his days as an outlaw. His mentality was best expressed by one of his adjutants, who explained to American correspondent John Reed why Urbina had taken up arms: "This Revolution, do not be mistaken, it is the fight of the poor against the rich. I was very poor before the Revolution and now I am very rich."[18] Urbina's main ambition was to become a hacendado and he attempted to amass wealth as quickly as he could.

Another subordinate of Villa's who was even more unpopular than Urbina was Rodolfo Fierro. Unlike Urbina, his interest in money was limited—not so his interest in killing. He executed prisoners and did so with unmitigated glee.

[17] Francisco L. Urquizo, *Recuerdo que…*, Instituto Nacional de Estudios Históricos de la Revolución Mexicana, Mexico, 1985, p. 387.

[18] John Reed, op. cit., p. 37.

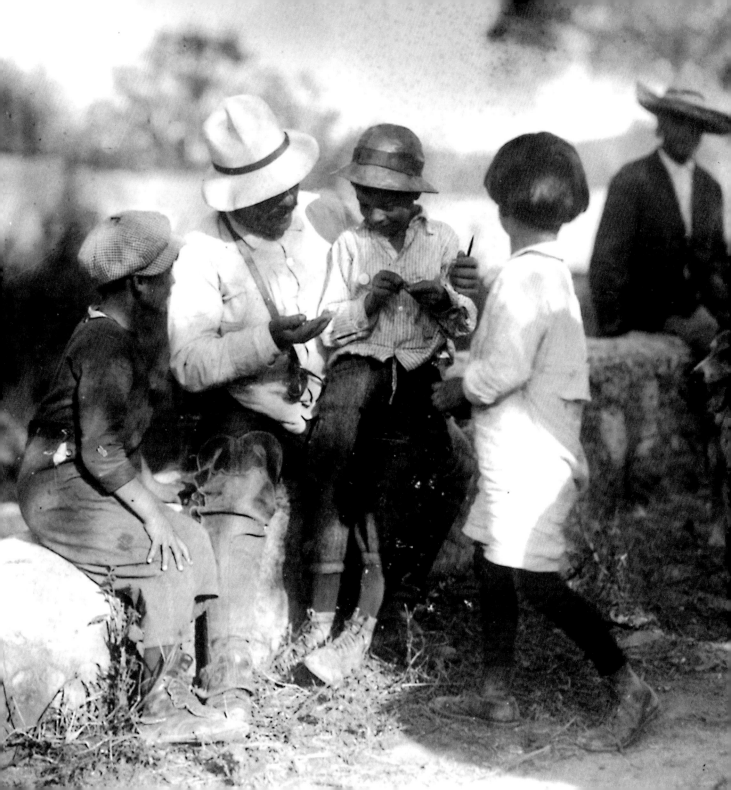

There were a number of highly educated men who had joined Villa's ranks, all of them former officials of Madero's government. They included the ex-education minister, Miguel Díaz Lombardo, and the former governor of the Federal district, a lawyer named Federico González Garza. Only two of these men were close to Villa and could thus be considered as the intellectual elite of Villismo.

The first of them was Silvestre Terrazas, an independent Chihuahuan newspaperman whose *Correo de Chihuahua* had fought without rest during the years of the Díaz dictatorship against the rule of the Terrazas-Creel clan in Chihuahua. It was Terrazas who drafted some of Villa's most important laws.

Still, the intellectual in whom Villa confided the most was not a civilian but a soldier, Felipe Ángeles. Ángeles, a high artillery officer in the Porfirian army, was a man full of contradictions that fitted no convenient catagory. He thus became an object of legend and controversy. To the end of his life, Ángeles admired Porfirio Díaz but became a convinced supporter of Madero. Unlike all other federal officers, he was loyal to his chief until the end. For that reason he was imprisoned and then exiled by Huerta and soon rejoined the Revolution. He was a professional soldier, but he was probably the most humane of Mexico's revolutionary leaders since he never shot his prisoners and frequently freed them. He was a socialist by conviction but was opposed to the confiscation of the wealth of the rich. He was a Mexican Nationalist but felt that only an alliance with the United States could guarantee democracy and stability in Mexico. He soon became one of Villa's most influential advisers, both in the formation of the Villista army and in the policies that Villa was pursuing.

Together with these men, Villa set out to transform the face of Chihuahua and of Mexico. When Villa assumed the governorship of Chihuahua, this former peon and outlaw with scarcely any education, without an organized political party, with no large group of well-trained professionals and intellectuals (most of the intellectuals who joined him did so a few months later) faced a tremendous task. He had to administer one of the economically most advanced states in Mexico. He would have to do so in a way that would gain him the support of the vast majority of the state's population. Without them, he would not be able to effectively fight the well-organized federal armies. He would

have to transform his group of largely undisciplined guerrillas into a well-organized army capable of facing the federal troops in battle.

He would also have to placate the other major revolutionary factions fighting against Huerta. There was the faction headed by Venustiano Carranza, centered in the state of Coahuila and Sonora, and the Ejército Libertador del Sur under the leadership of Emiliano Zapata. Finally he would have to gain the goodwill of the Americans. This was not only necessary to prevent an American intervention—there were large American investments in Chihuahua—but also to be able to secure ammunition in the United States in order to equip his army.

To the surprise of most observers he was—at least for a time—successful in all of these endeavors.

The cornerstone of this policy was a decree that he issued on December 21, 1913. He announced the temporary expropriation, called intervention, of the holdings of Mexican oligarchy in Chihuahua. In addition, in all areas occupied by his troops, many Spaniards were expropriated and expelled.

Once the Revolution had triumphed, this property was to serve several purposes: to finance pensions for the widows and orphans of revolutionary soldiers; to give land to veterans of the Revolution; and to restore to all villages the lands that had been expropriated by the hacendados. The justifications that Villa gave for these measures were based not only on social justice and on the fact that many of the hacienda lands had been taken from villages, but also on the fact that hacendados owed huge amounts of money to the state since they had consistently underpaid their taxes. Villa's predecessor, Governor Abraham González, had established that while the value of the Terrazas properties lay between 50,000,000 and 100,000,000 pesos, his properties were valued at 1,700,000 pesos for tax purposes. This meant that Terrazas paid practically no taxes on his huge holdings.

As a result of this expropriation, Villa's government suddenly acquired huge amounts of wealth. Villa named newspaperman Silvestre Terrazas to administer both the confiscated haciendas and urban holdings of the oligarchy.

The first beneficiaries of these measures were the vast majority of Chihuahua's population. Large amounts of beef were sent to the markets of Chihuahua and their price was drastically reduced. "Unemployed Mexicans from the devastated lumber and mining operations are being provided with daily rations…by the Constitutionalist Army," a U.S. newspaper reported. [19] On some confiscated estates, sharecroppers no longer had to pay part of their crop to the hacienda administration. Large amounts of food were supplied to children's homes and orphanages.

As a result of these measures, Villa became known throughout Chihuahua "as the friend of the poor." Unlike Emiliano Zapata in southern Mexico, Villa carried out no immediate division of hacienda lands. Villa needed the proceeds from the confiscated haciendas to buy arms in the United States and to finance his welfare programs. Zapata had no such options since the territories he controlled had no border with the United States. Villa's aim was to implement a large-scale land reform only when the Revolution was victorious.

Villa's success in gaining massive popular support in the areas he controlled was matched by his success in forging a very heterogeneous group of largely undisciplined guerrillas into an effective fighting force. Edwin Emerson, a newspaperman and a secret agent of U.S. Chief of Staff Leonard Wood, was greatly impressed by the Division del Norte. He spent several months witnessing its greatest battles. Emerson called the men of the Division del Norte "the best setup, best armed, best mounted, best equipped, best clothed, best fed, best paid and generally best cared for troops I have yet seen in Mexico." [20]

For a time, Villa succeeded in gaining widespread support in the United States, ranging from the Wilson Administration to large American business interests as well as to the American Left. What the Wilson Administration and the business interests admired was the discipline that Villa was able to keep when his troops occupied a city. All bars were closed and any soldier engaged in looting was immediately executed. "Every one expressed great praise of General Villa," the U.S.

[19] *El Paso Times*, January 17, 1914.

[20] National Archives, Military Intelligence Department, 5761-1091-31, box 2348, Edwin Emerson to Leonard Wood, May 14, 1914

consul of Torreon reported after the capture of the city "as a leader in being able to maintain such order." [21]

This support was enhanced by the fact that, in order not to lose access to American arms and supplies, Villa did not confiscate or touch American properties in any way. For leftists in the U.S.— above all for one of its most brilliant writers John Reed—Villa, because of his massive redistribution of goods, became the personification of social revolution in Mexico.

What Villa was unable to achieve was any kind of permanent agreement with the other major revolutionary faction that had revolted in the north. It was headed by the governor of the state of Coahuila, Venustiano Carranza. What separated the two men was far more than their differing social origins—Villa had been a peon on a hacienda while Carranza, a hacendado, had held important positions in the Díaz administration. Villa was intent on destroying the hacienda system. But Carranza was convinced that if this were the case and the hacienda lands were divided among the country's peasants, the peones would turn to subsistence crops and the Mexican agricultural economy would be destroyed. Unlike Porfirio Díaz, under whom a small oligarchy had held power in Mexico, Carranza wanted to include the middle classes but not the popular classes in the governments of Mexico. Villa on the other hand was intent on giving a voice to the poorest segments of society. Carranza wanted a civilian government and in his eyes Villa incarnated the rebellious military. Carranza was a nationalist who profoundly distrusted the United States while Villa, for a time, believed that the Wilson Administration wanted social and economic changes in Mexico and respected the country's independence. These differences not only reflected personal differences but also differences in the constituencies of the two men. Agrarian problems had been much more acute and expropriations much larger in the major areas controlled by Villa—Chihuahua, Durango and the Laguna area—than those under the control of Carranza.

In spite of their differences, the two factions uneasily cooperated until Huerta suffered a major defeat. After that a major split occurred, with Carranza and the generals and military forces loyal to him on the one hand, and Villa and a newfound ally, Emiliano Zapata, on the other. Although wooed

[21] State Department Files, 812-00-9658, George C. Carothers to the State Department, October 15, 1913.

by Carranza, Zapata had recognized that Villa was the one other revolutionary leader who shared his agrarian ideals.

There was another important ideological and practical difference that separated Carranza and his faction from the Villistas and Zapatistas. This was the question of whether Mexico should have a strong or weak central government. Villa and Zapata and their peasant supporters were convinced that a strong central government would lead to an attack on their autonomy and their land. Carranza on the other hand believed that only a strong central government could preserve the country's independence.

In the civil war that now ensued, General Álvaro Obregón—a member of Carranza's army—showed himself to be superior in military capacities to both Zapata and Villa. He had studied the tactics of World War I and learned that cavalry had become obsolete. In a series of decisive battles, the most important of which was the battle of Celaya, Obregón set up trenches with barbed wire and machine gun nests and mowed down the attacking Villista cavalry.

In the last phase of that Civil War, the Americans sided with Carranza, broke their official neutrality and allowed Carranza's troops to ride on trains through the United States to reach Sonora and inflict a decisive defeat on Villa in that state.

Villa was now a defeated man. Most of his army had either been destroyed or deserted him and only a few hundred men were still following him. At this point, the American government offered him asylum and Villa now had the possibility of doing what so many traditional caudillos such as Batista from Cuba and Somoza from Nicaragua had done: take a large part of the state treasury, flee into exile and lead a good and rich life there. Villa could have done the same. He exercised a large degree of control over the state treasury of Chihuahua and the United States had offered him asylum. He could easily have crossed the border and led a good life with as many wives as he wanted. He would certainly have acted in this way had he been the bandit that his enemies portrayed him to be. Instead he chose to remain in Chihuahua and wage guerrilla warfare for five years under the most difficult conditions.

The help given Carranza by the United States had convinced Villa that Carranza had agreed to transform Mexico into an American colony. This belief, which was erroneous, was fostered by the

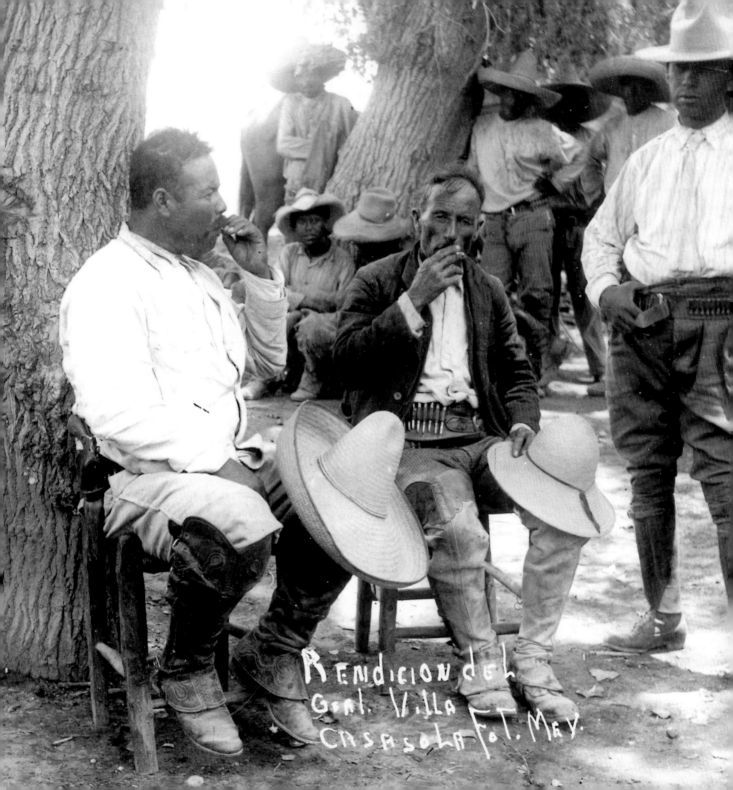

Rendicion del
Gral. Villa
Casasola Fot. Mey.

fact that the head of the state department's Mexican desk, Leon Canova, had offered Villa recognition if he would agree to name candidates proposed by the United States to be secretaries of the interior of foreign affairs and of commerce and to give the U.S. military bases in Baja California. Villa had refused and now assumed that Carranza had agreed to these same terms and had thus become an agent of the United States (which was not the case).

Villa now decided that the one way to either expose Carranza as an American agent or to prevent him from getting any American aid was to provoke a conflict with the United States. With several hundred men, he attacked the town of Columbus, New Mexico. As he had expected, an American expedition of 7,000 to 10,000 men crossed into Mexico trying to capture him. Another 10,000 Carrancistas entered Chihuahua with a similar aim. Yet neither was successful.

In fact, by the end of 1916 Villa once more had between 7,000 and 10,000 men at his command and had succeeded in briefly capturing the city of Chihuahua. In twenty-two battles, he defeated the Carrancistas again and again, but he had neither the men nor the resources to once more effectively control Chihuahua and large parts of the north. Many of the northern inhabitants were simply tired of fighting and did not want to join Villa or any other faction. His access to American arms and ammunition, which would have allowed him to transform his guerrilla force into a regular army, had been cut off first as a result of the U.S. recognition of Carranza and later as a result of his attack on Columbus. Still the attack had had one positive consequence for Villa. In view of Carranza's hostility to American troops in Mexico, the U.S. had decreed an arms embargo against Carranza who thus was not able to defeat Villa, Zapata or other popular forces. On the other hand, neither Villa nor Zapata nor the popular forces had the strength to topple el Primer Jefe.

When Carranza was overthrown by a military rebellion led by Álvaro Obregón, Villa was willing to make his peace with the government. From the government, Villa requested the right to set up a police force with which he would control southern Chihuahua. The government refused and instead offered Villa a hacienda, land to his men, and an escort of fifty of his former soldiers which would be paid for by the government. Villa finally accepted and lived his last three years on his hacienda of Canutillo. While he had largely withdrawn from politics and took care of his estate, he had not

simply become a hacendado who was indifferent to the plight of the popular classes which he had led for so long. On his own hacienda, he established one of the best schools in Mexico, open to the children of his own laborers and to the peasants surrounding his hacienda. By sending a sharp and threatening letter to Obregón, he prevented the huge complex of Terrazas' haciendas from being sold to an American entrepreneur and forced the government instead to buy them and begin to divide them among the peasants.

He was assassinated in July 1923 by orders of Obregón and Plutarco Elías Calles—the minister of the interior and Obregón's eventual successor as president. Both feared that Villa might take part in an uprising against them, but they also seemed to have been strongly influenced in this by American representatives. An agent of the U.S. Bureau of Investigation (the predecessor of the FBI) Manuel Sorola reported, "A reliable source states that when Calles was notified of Villa's assassination, his only comment was 'the second of the fundamental conditions imposed by the United States as necessary to recognition had been complied with.'"[22]

For many years successive Mexican governments tried either to convert Villa into a nonperson or simply designate him as a bandit, but they did not succeed. "There is no doubt that history is written by the victors," one of Villa's admirers stated, "but it is also true that legends are written by the people...for that reason the name of Francisco Villa has remained enshrined forever in the heart of the poor."[23]

This was indeed true and Villa remained one of the most popular and best-known leaders of the Mexican Revolution. They remembered that apart from the Zapatistas it was Villa's faction that had done most to distribute goods to the poor. They also knew that Villa had done more than any other leader in the armed phase of the Mexican Revolution to destroy the old regime. He had taken the initiative in capturing Ciudad Juárez in 1911 and had thus inflicted a decisive defeat on Díaz' army.

In 1913-14, he had done more than any other Mexican leader to destroy the Huerta regime. His attack on Columbus and the break between Carranza and the United States that this entailed pre-

[22] Bureau of Investigation Files, 78149, Manuel Sorola to the Bureau of Investigation, August 20, 1923.

[23] Óscar W. Ching Vega, *La última cabalgata de Pancho Villa*, Centro Librero La Prensa, Chihuahua, 1977, p. 140.

vented Carranza from obtaining arms in the United States and completely destroying and defeating the Villistas and Zapatistas and other popular forces who continued to be a viable force in their own states. The feelings of the popular classes towards Villa are perhaps best expressed in the many corridos that continue to be sung all over Mexico.

Pobre Pancho Villa.
Fue muy triste su destino.
Morir en una emboscada.
Y a la mitad del camino.

Ay, Mexico está de luto.
Tiene una gran pesadilla.
Pues mataron en Parral
al valiente Pancho Villa.

Poor Pancho Villa.
His fate was a sad one.
To die in an ambush
in the middle of the road.

Ay, Mexico is in mourning
It has a great nightmare
Because they killed in Parral
The brave Pancho Villa.[24]

[24] Vicente T. Mendoza, op. cit., pp. 67-69.

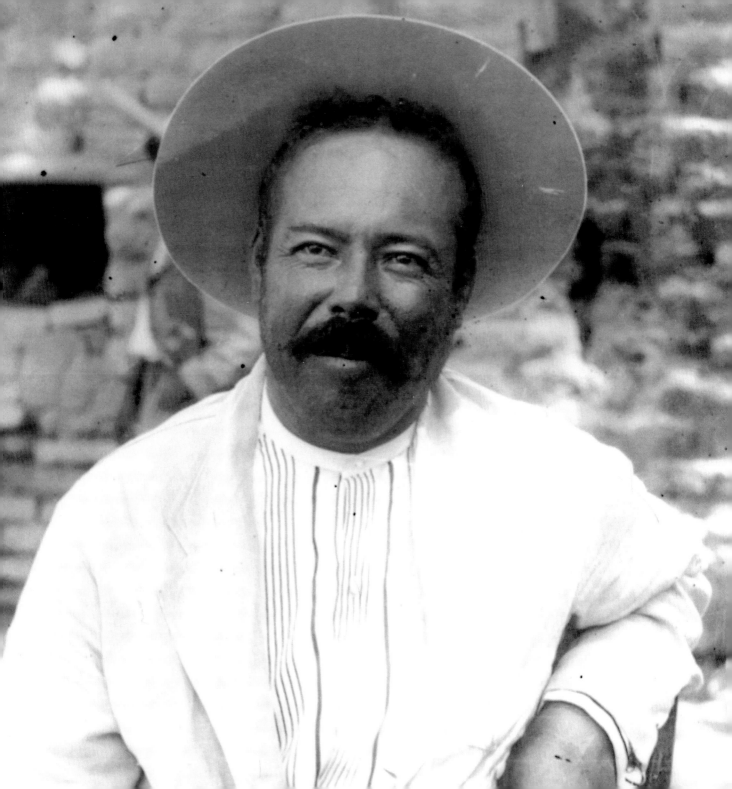

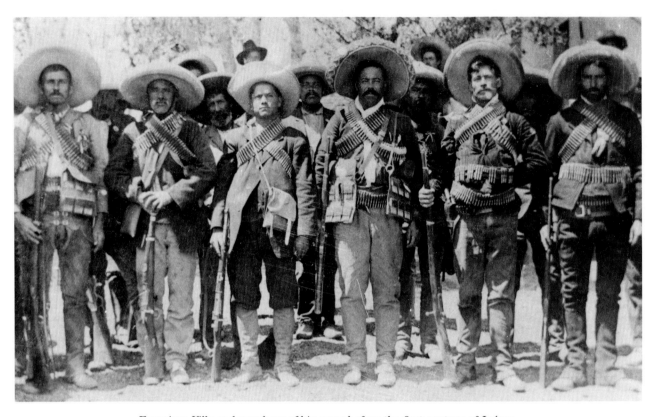

Francisco Villa and members of his army before the first capture of Juárez.
(Casasola Collection 6194, Ciudad Juárez, Chihuahua, May 1911, safety film.)

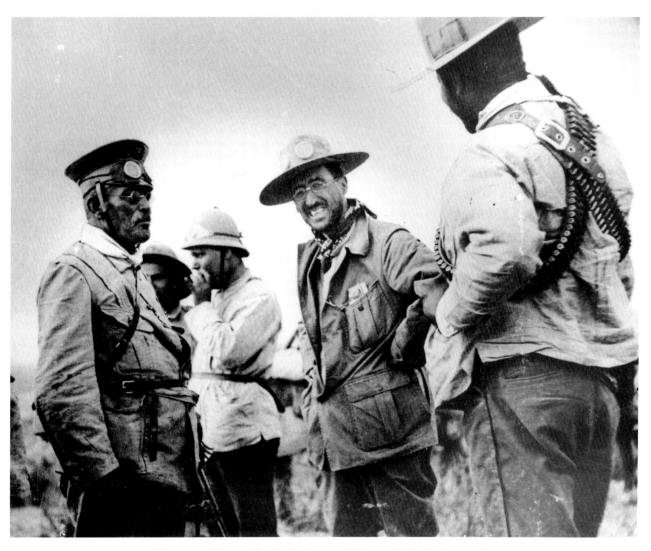

Victoriano Huerta, Emilio Madero and Villa (with his back turned).
(Casasola Collection 6192, Ciudad Chihuahua, May 1912, dry gelatin plate.)

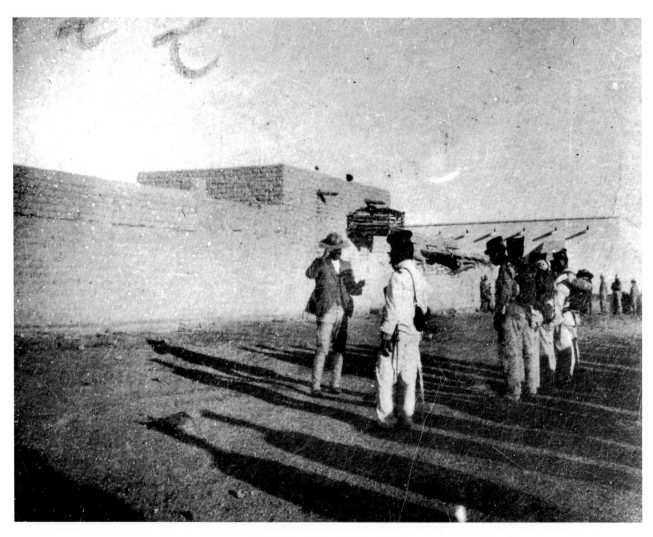

Villa talks to the firing squad.
(Casasola Collection 68175, Sonora, ca 1912, nitrocellulose film.)

Santiago Armendáriz and Francisco Villa.
(Casasola Collection 68042, Chihuahua, April 1912, safety film.)

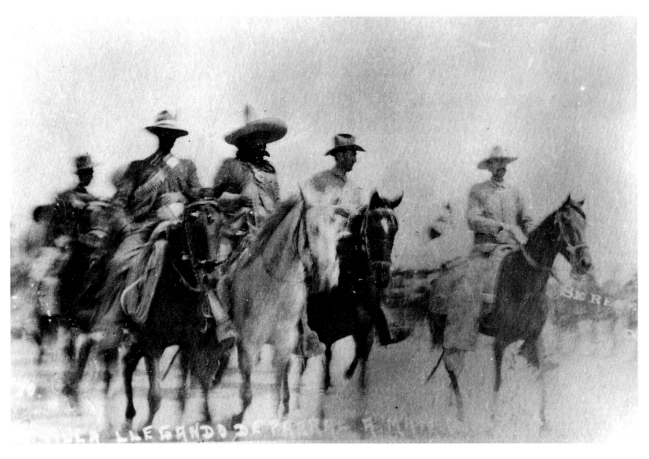

Villa traveling from Parral to Mapimí with Raúl Madero.
(Casasola Collection 68116, Mexico City, 1912, nitrocellulose plate.)

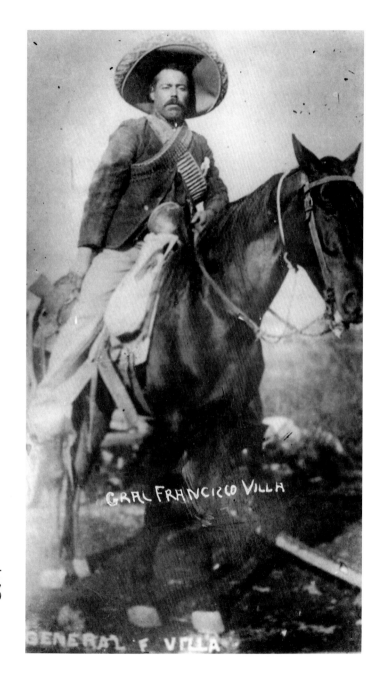

General Francisco Villa.
(Casasola Collection 65107,
Mexico City, 1920-1923, dry gelatin plate.)

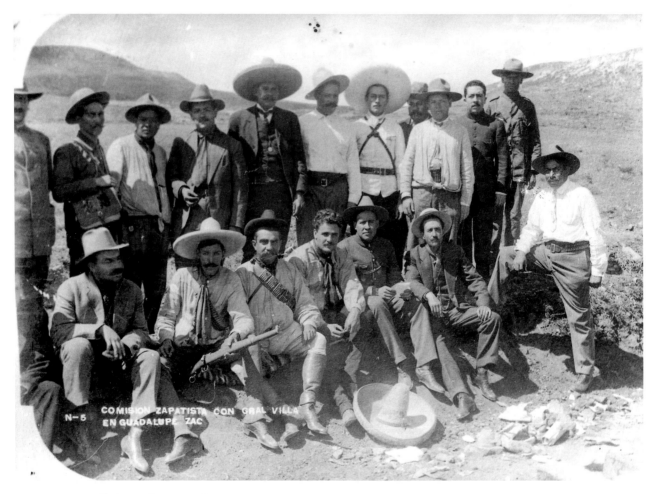

Eufemio Zapata and "the Zapatista delegation with General Villa in Guadalupe, Zacatecas."
(Casasola Collection 276244, Guadalupe, Zacatecas, ca 1914, nitrocellulose plate.)

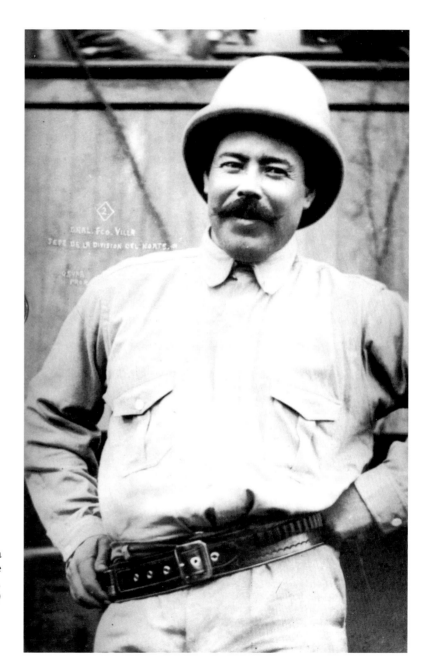

General Francisco Villa
of the División Del Norte
(Casasola Collection 6062, 1914,
nitrocellulose plate.)

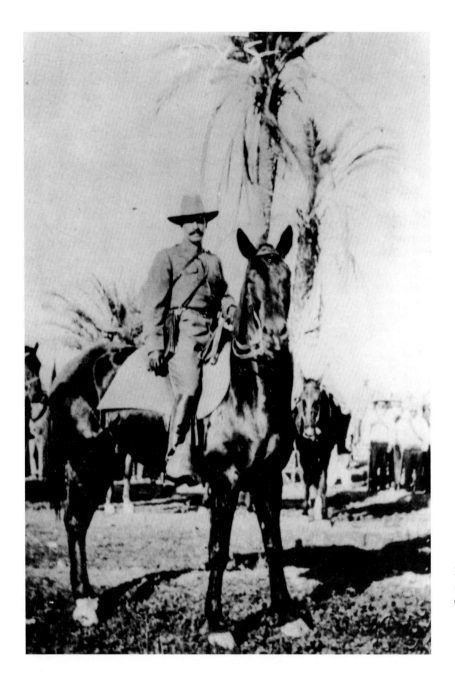

Felipe Ángeles.
(Casasola Collection 287515, ca 1914, nitrocellulose slide.)

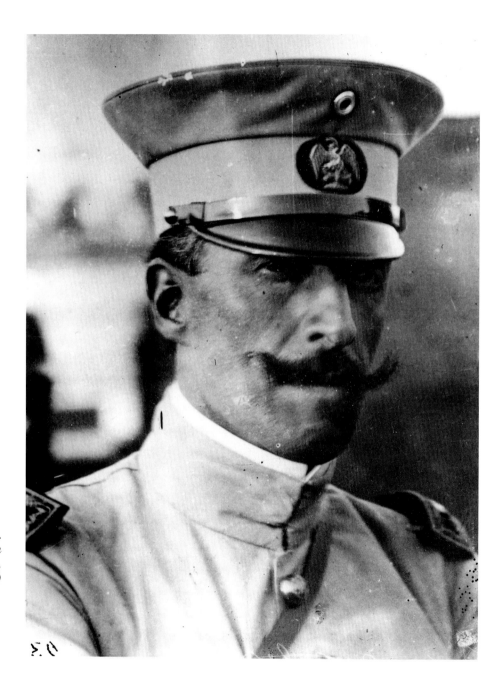

Felipe Ángeles.
(Casasola Collection
287526, ca 1915,
safety film.)

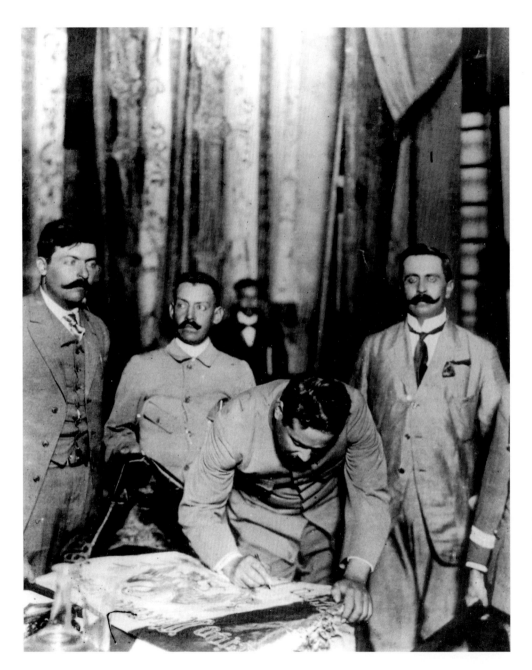

Villa signing the flag
at the Aguascalientes
Convention.
*(Casasola Collection
287641, 1914, dry
gelatin plate.)*

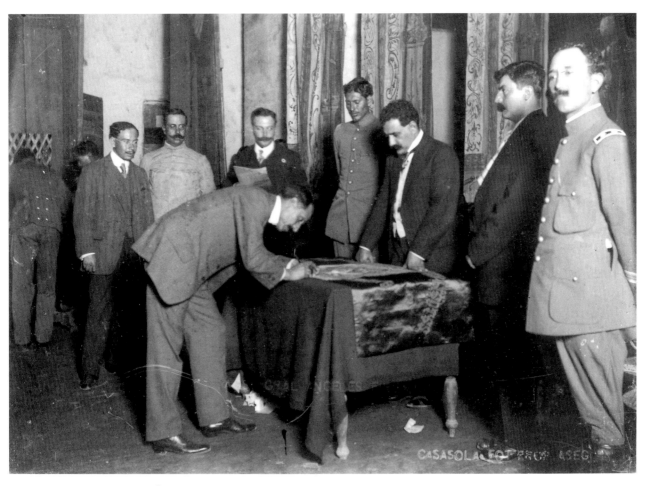

Ángeles signing the national flag at the Aguascalientes Convention.
(Casasola Collection 39085, 1914, dry gelatin plate.)

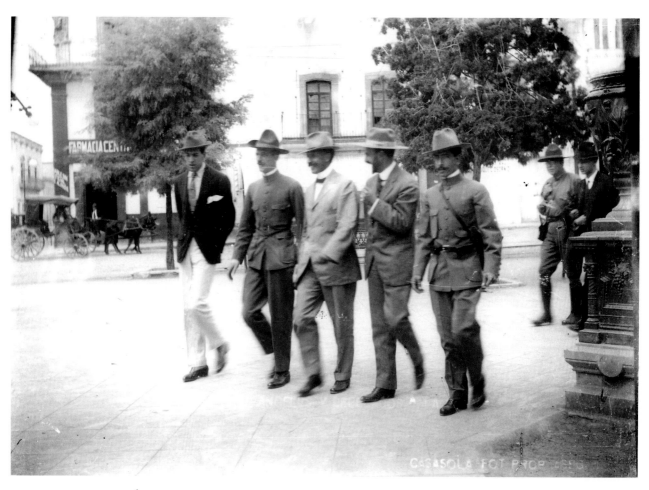

Felipe Ángeles and his senior staff walking to the Teatro Morelos, in Aguascalientes.
(Casasola Collection 39090, 1914, dry gelatin plate.)

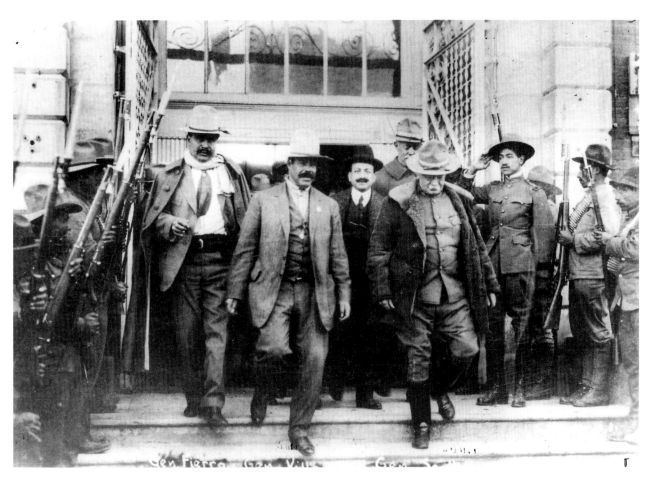

General Fierro, General Villa and General Scott.
(Casasola Collection 186386, ca 1917, nitrocellulose plate.)

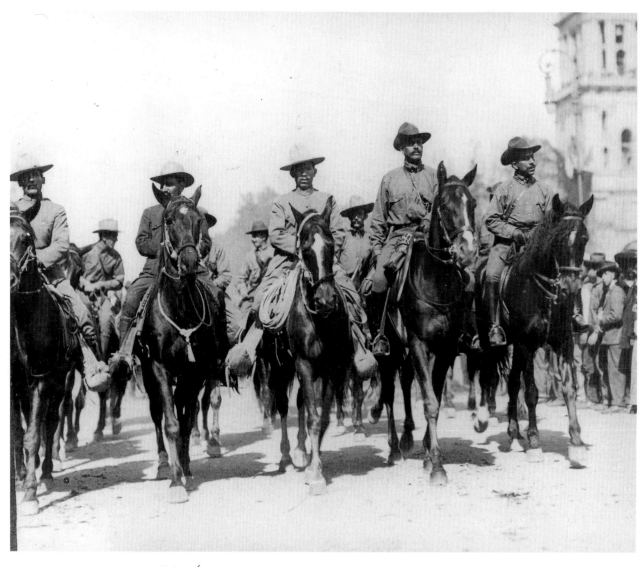

Felipe Ángeles with convencionista troops entering Mexico City.
(Casasola Collection 287542, Mexico City, December 1914, safety film.)

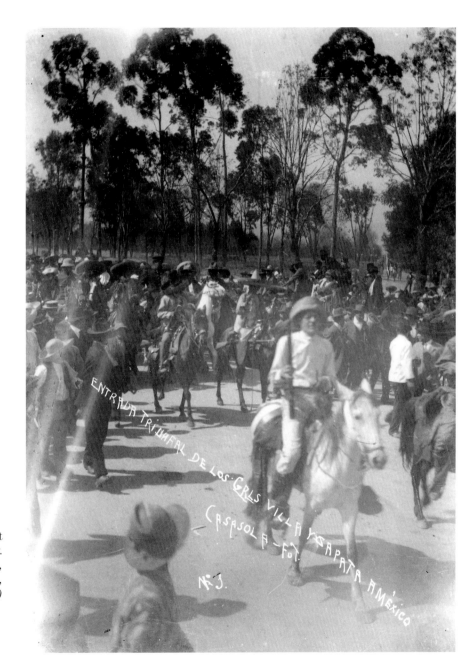

Villa and Zapata's triumphant entry into Mexico City. *(Casasola Collection 5235, Mexico City, December 6, 1914, dry gelatin plate.)*

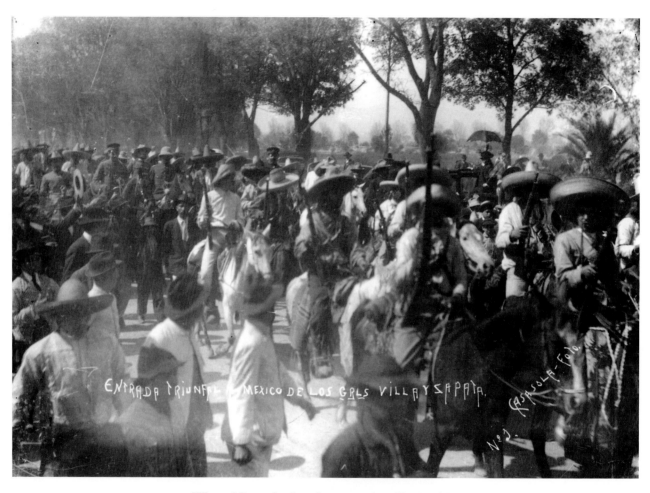

Villa and Zapata's triumphant entry into Mexico City.
(Casasola Collection 5333, Mexico City, December 6, 1914, dry gelatin plate.)

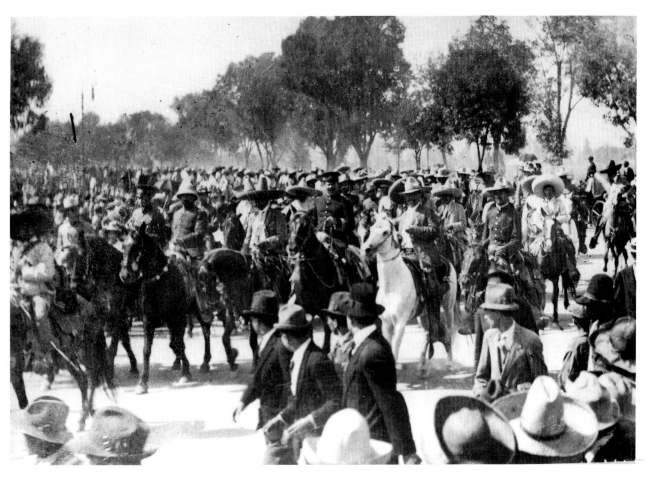

Zapata and Villa at the head of the convencionista army.
(Casasola Collection 6131, Mexico City, December 6, 1914, safety film.)

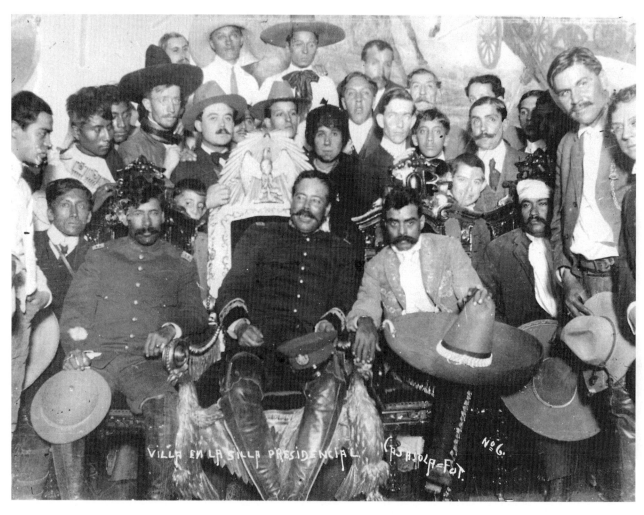

Villa in the presidential chair.
(Casasola Collection 186381, Mexico City, December 6, 1914, safety film.)

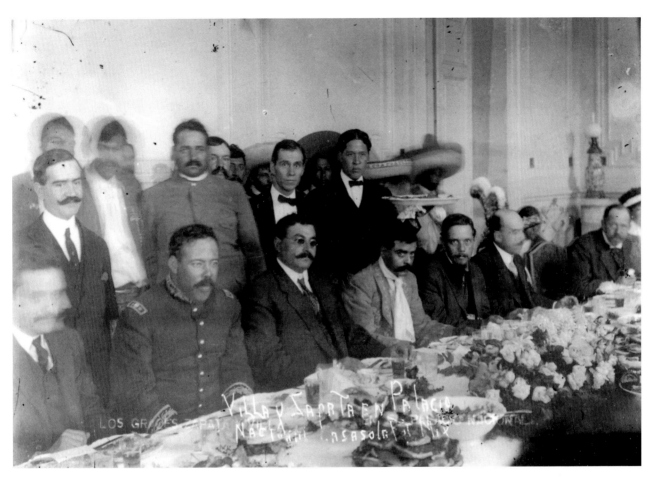

Villa and Zapata in the Palacio Nacional with Eulalio Gutiérrez, José Vasconcelos and others.
(Casasola Collection 5656, Mexico City, December 1914, dry gelatin plate.)

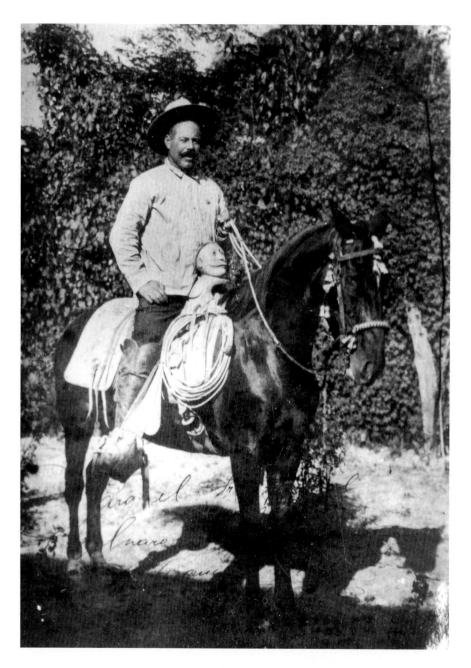

(Casasola Collection 66201, 1914-1920, safety film.)

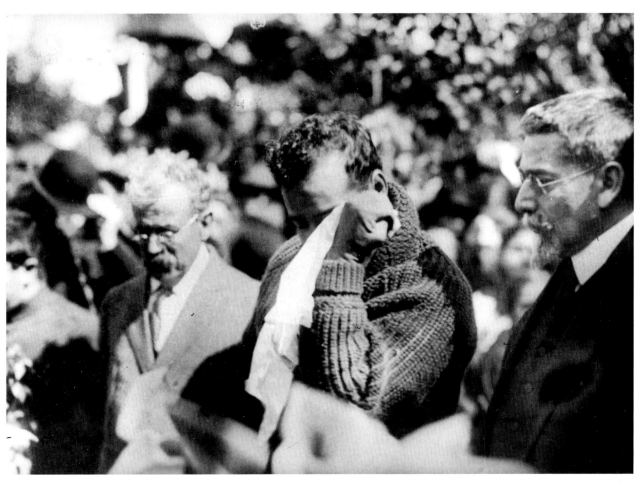

Villa crying at the burial of Madero.
(Casasola Collection 6048, Mexico City, December 8, 1914, nitrocellulose plate.)

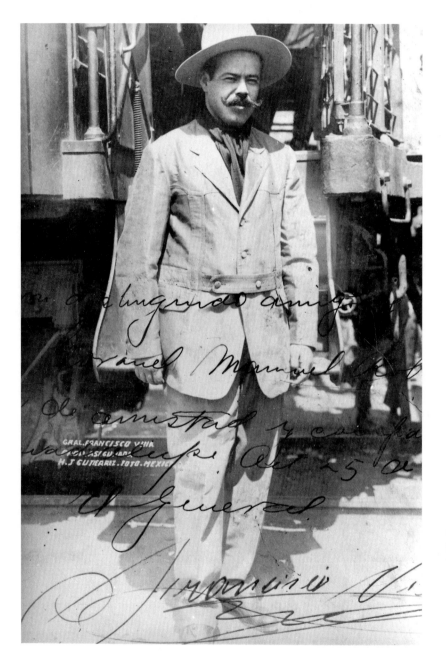

"To my distinguished friend, Cornel Manuel Chao […] with friendship, Guadalupe, October 5 […], the General Francisco Villa." *(Casasola Collection 66109, 1914-1920, safety film.)*

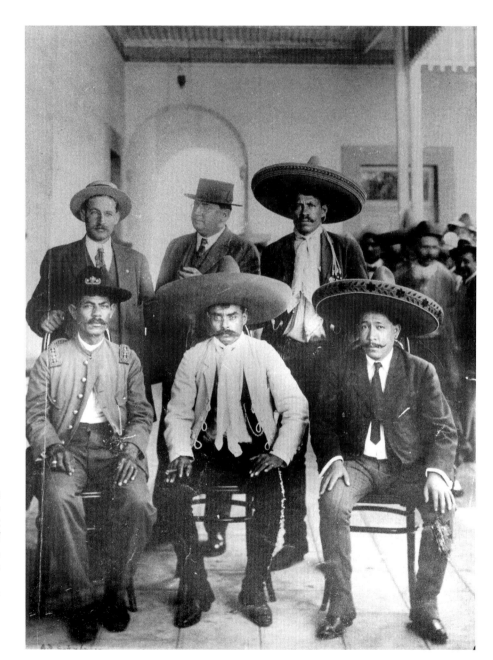

Emiliano Zapata accompanied by Benjamín Argumedo, Manuel Palafox and others, before the visit of Pancho Villa, in Xochimilco, outside of Mexico City. *(Casasola Collection 6244, 1914, dry gelatin plate.)*

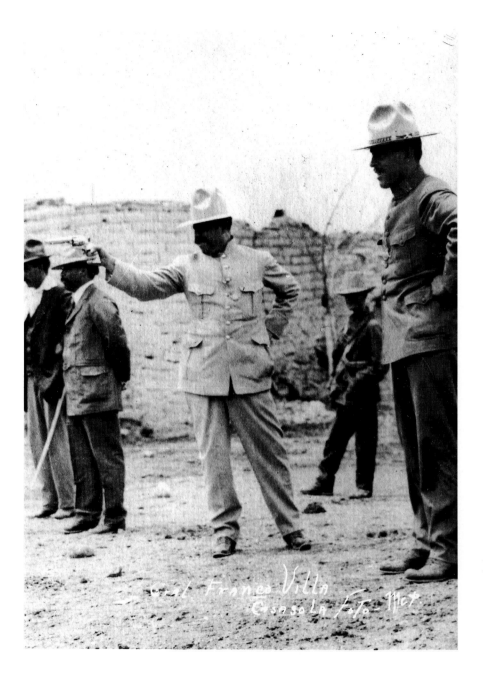

(Casasola Collection 287645,
Mexico City, ca 1914,
nitrocellulose plate.)

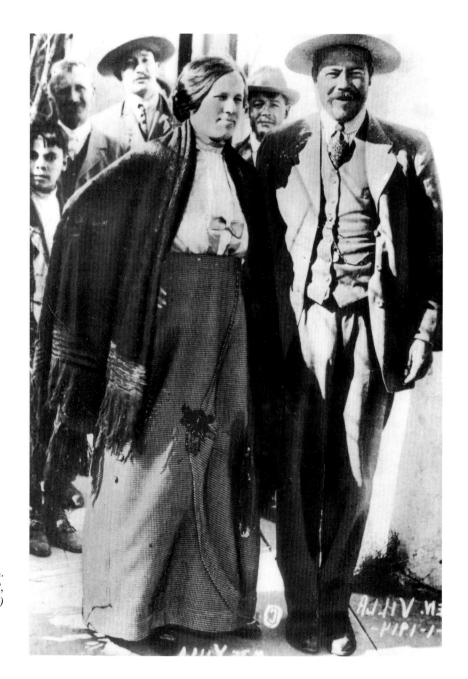

Villa and wife Luz Corral, 1914.
(Casasola Collection 197542,
Durango, 1914, safety film.)

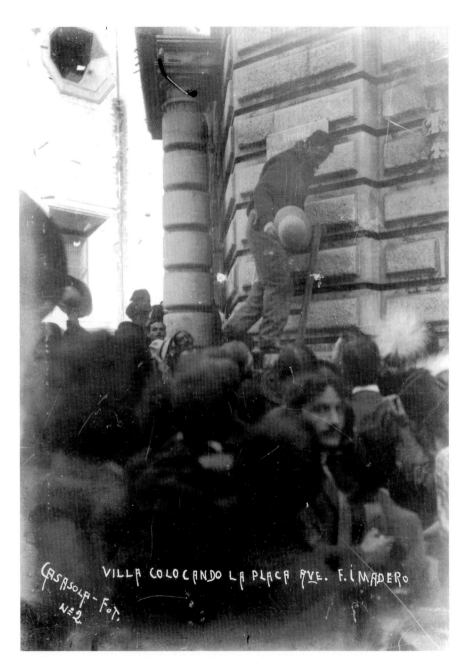

VILLA COLOCANDO LA PLACA AVE. F.I. MADERO

CASASOLA-FOT. Nº 2

Villa putting up the street sign, "Ave. F.I. Madero." *(Casasola Collection 5244, Mexico City, December 8, 1914, dry gelatin plate.)*

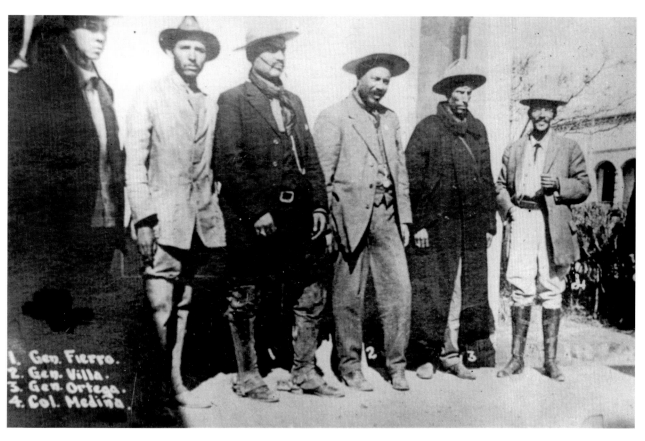

General Fierro, Villa, Ortega and Medina.
(*Casasola Collection 68176, ca 1913, dry gelatin plate.*)

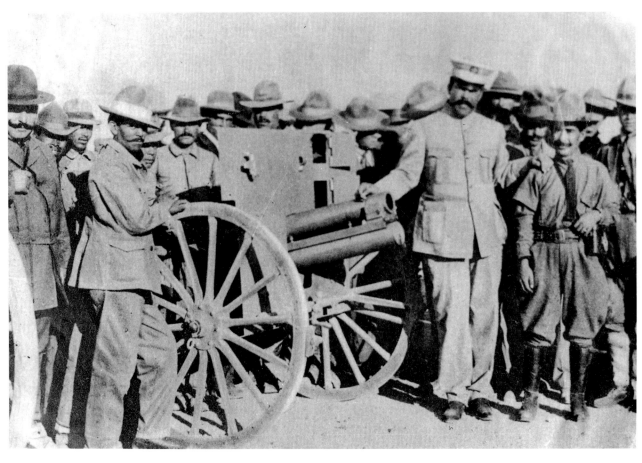

Villa with an artillery canon.
(Casasola Collection 287650, ca 1915, safety film.)

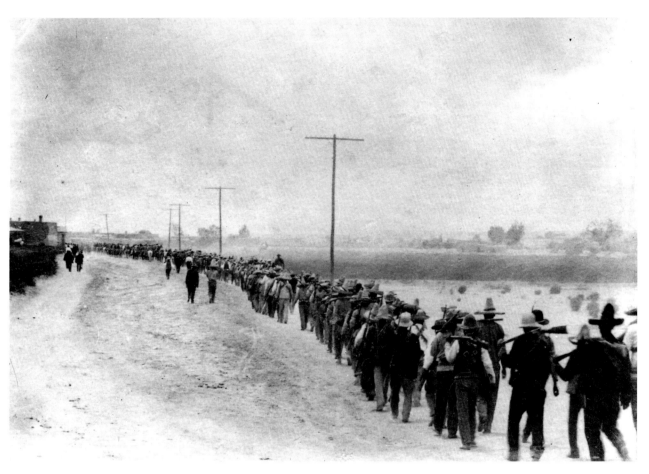

Villista troops in Columbus, New Mexico.
(Casasola Collection 64220, March 1916, nitrocellulose plate.)

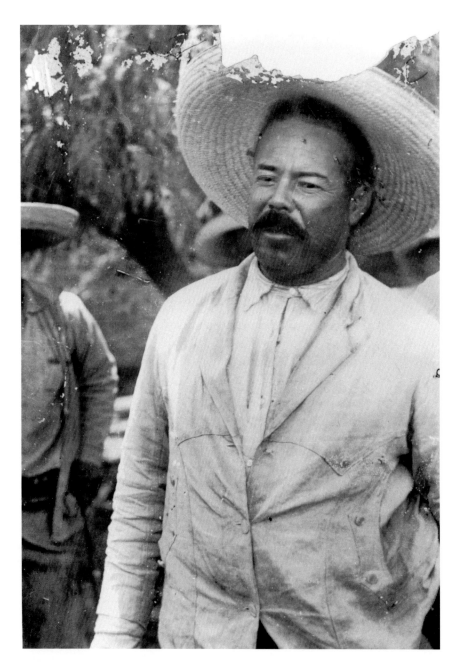

(Casasola Collection 66063, 1914-1920, nitrocellulose slide.)

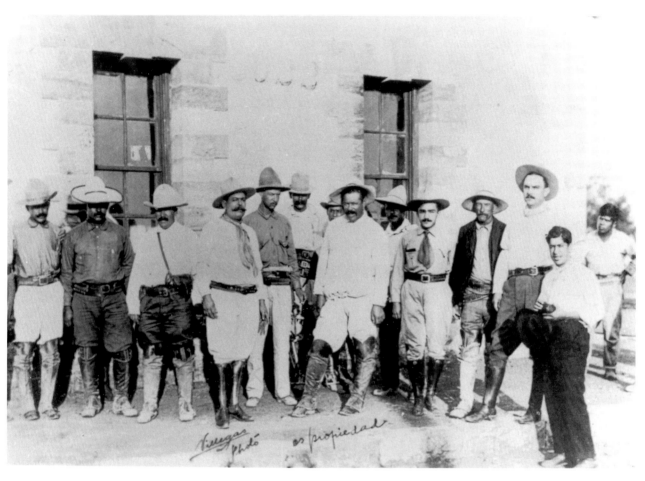

Villa with members of his senior staff.
(Casasola Collection 33424, ca 1916, safety film.)

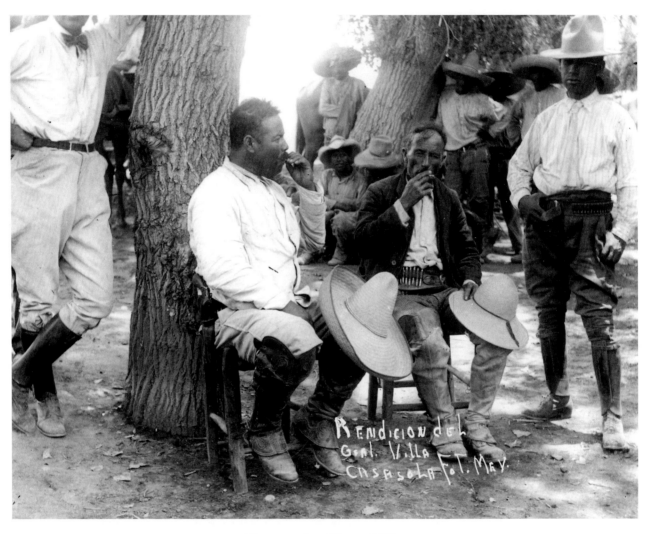

The surrender of General Villa.
(Casasola Collection 5755, Sabinas, Coahuila, July 28, 1920, dry gelatin plate.)

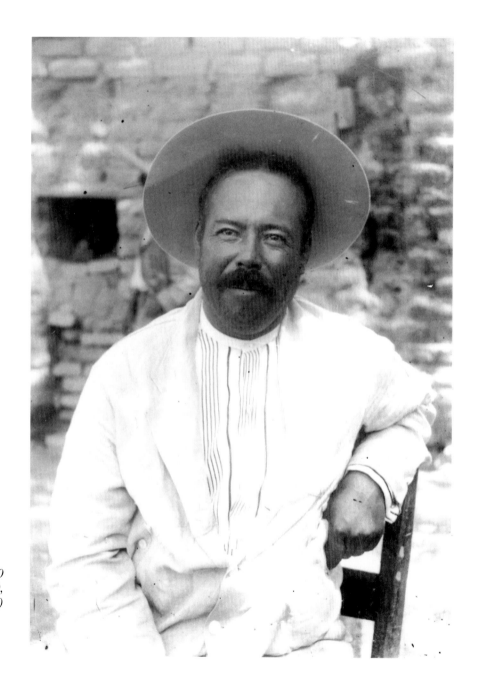

*(Casasola Collection , 5770
Sabinas, Coahuila, July 28 ,1920,
dry gelatin plate.)*

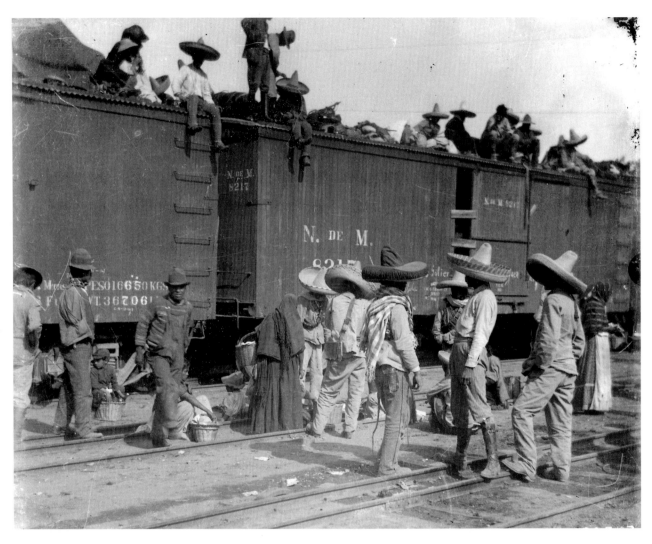

Troops from the División del Norte boarding a train.
(Casasola Collection 5284, Mexico, ca 1918, dry gelatin plate.)

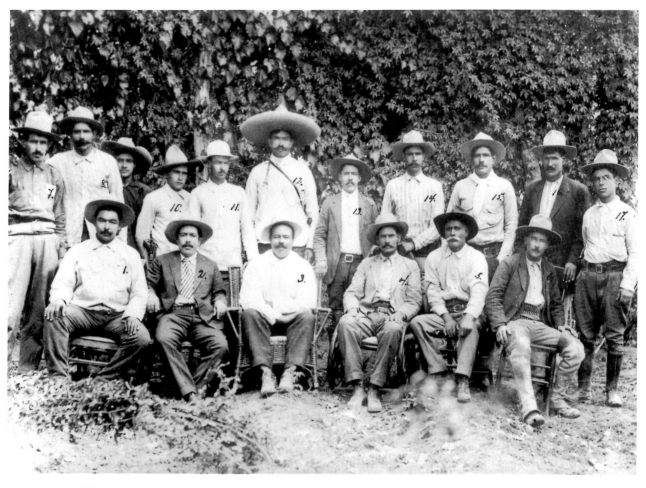

Villa with members of his senior staff a little after taking possession of the Canutillo hacienda.
(Casasola Collection 33427, Chihuahua, ca 1920, nitrocellulose plate.)

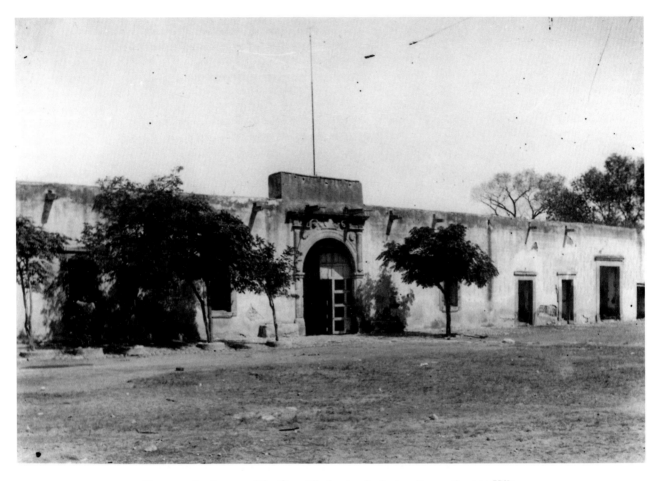

House and entrance of the Canutillo hacienda, just as it was given to Villa.
(Casasola Collection 65447, Durango, ca 1920, dry gelatin plate.)

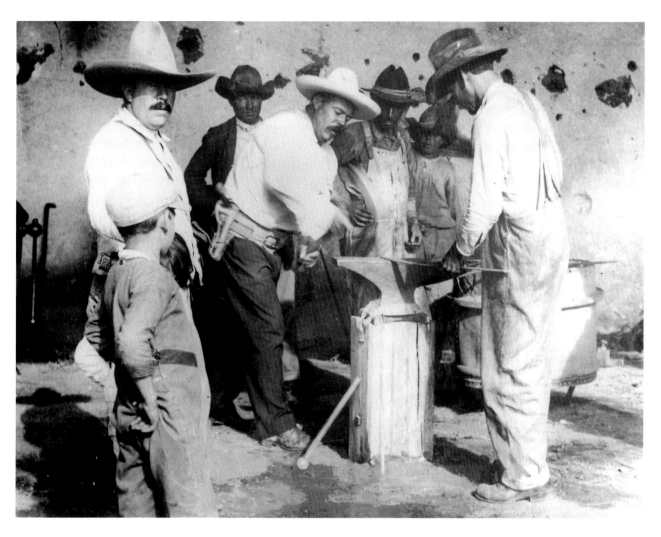

Francisco Villa in the blacksmith shop at Canutillo.
(Casasola Collection 6138, Durango, 1920, safety film.)

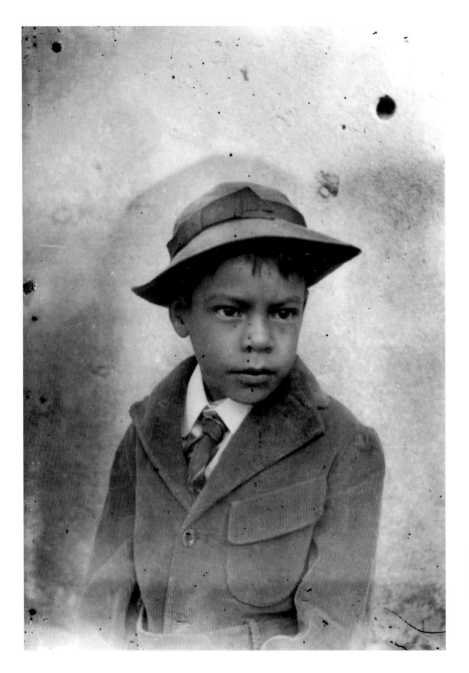

Hipólito, son of Francisco Villa.
(Casasola Collection 68237,
Durango, ca 1920,
dry gelatin plate.)

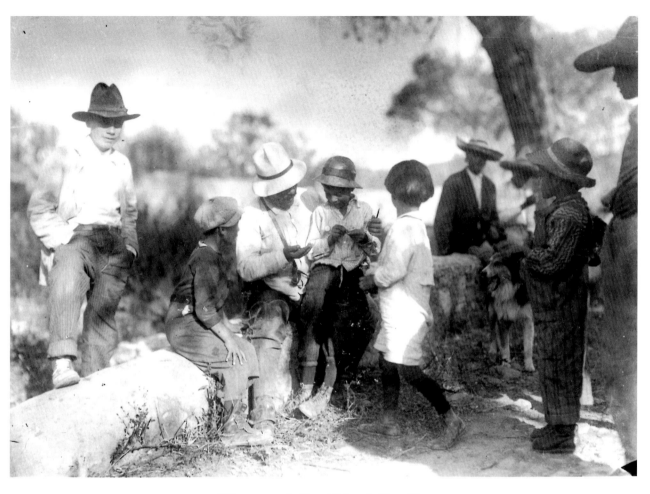

Villa surrounded by children in Canutillo.
(Casasola Collection 5322, Durango, ca 1923, dry gelatin plate.)

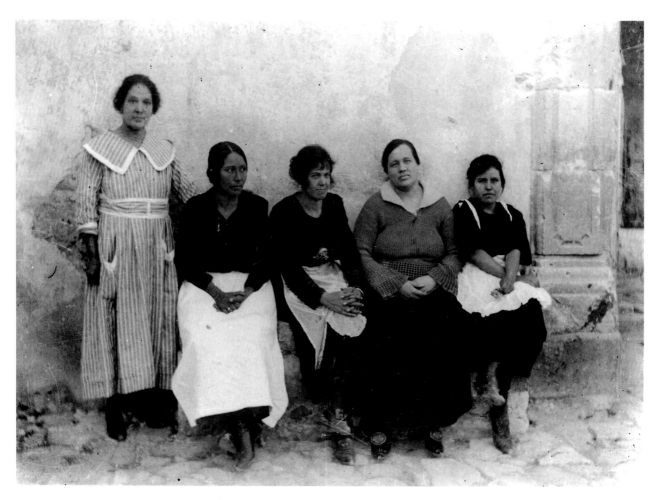

Luz Corral and relatives at the hacienda of Canutillo.
(Casasola Collection 5343, Durango, 1923, nitrocellulose plate.)

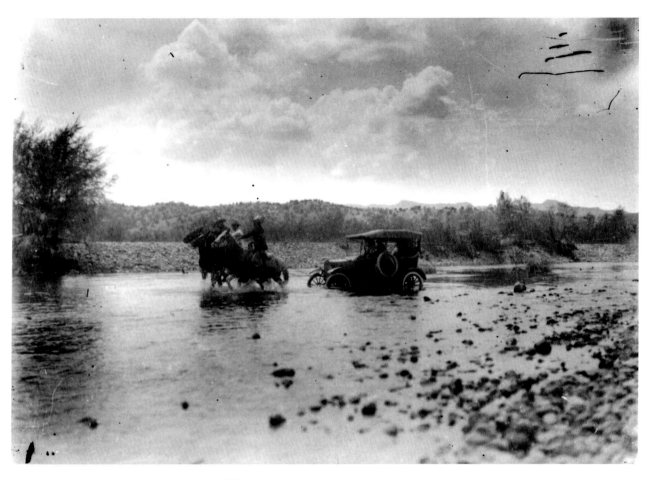

Villa's car pulled by men on horseback.
(Casasola Collection 68236, Durango, 1922, dry gelatin plate.)

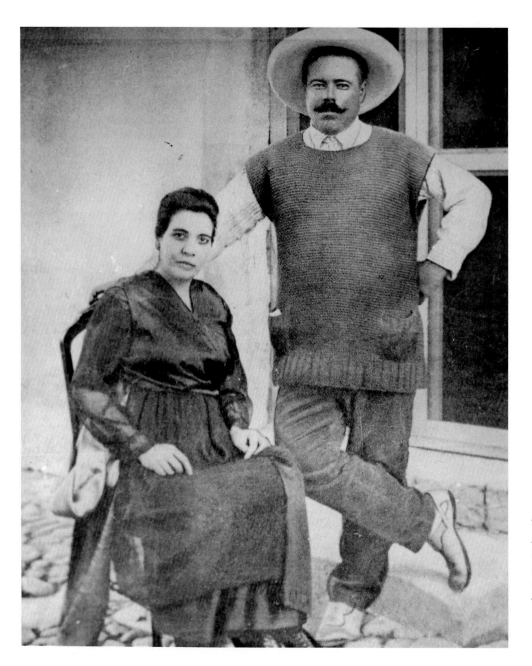

Villa with
Austreberta Rentería.
*(Casasola Collection
66076, Mexico,
1921-1923,
safety film.)*

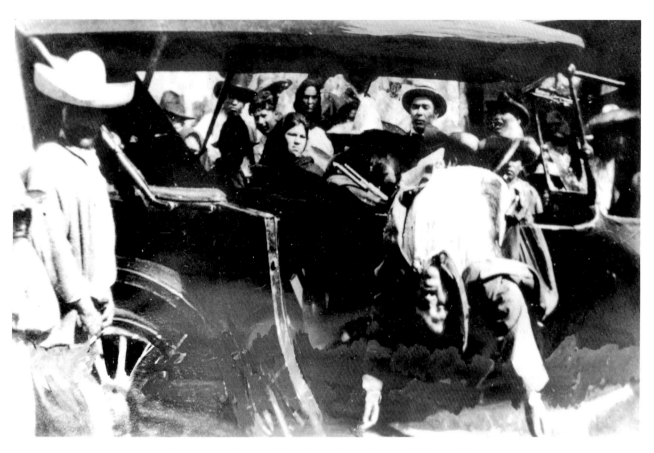

The death of General Francisco Villa and Cornel Miguel Trillo.
(Casasola Collection 68190, Parral, Chihuahua, July 20, 1923, safety film.)

The Casasola Collection

The photographic editors of *The Face of Pancho Villa*—Heladio Vera Trejo, Paula Alicia Barra Moulain, Guadalupe Hernández Hernández and Pedro Edgar Guerrero Hernández—selected the photographs in this book from the vast archives of the Casasola Collection at Mexico's Fototeca Nacional in Pachuca. The Casasola Collection, by dint of its size and stature, has developed a near monopoly on the iconography of the Mexican Revolution.

The Mexican government purchased the Casasola Collection in 1976 from the heirs of Agustín Victor Casasola. An institution in the United States had sought to acquire the collection, but the Mexican government stepped in with its own proposal as part of its efforts to keep its cultural legacy inside the country. The photographs in the archive cover the period from the dawn of the century to 1972, but the photographs documenting the Mexican Revolution are its heart and soul.

The importance of these images, however, has been neglected. Historian David Romo points out that Susan Sontag wrongly regarded the Spanish Civil War as the first war to be widely documented by modern photography. In her book *On Photography* Sontag states that governments had kept a tight reign on photographers during the American Civil War and later (post-Mexican Revolution) during World War I, limiting their access to the battlefront. Ignoring the Mexican Revolution, Sontag saw the Spanish Civil War as the first conflict to allow all access passes to photojournalists. But Romo argues that the Mexicans had the Spaniards beat by a couple of decades. Photographers had nearly unfettered access to the Mexican Revolution. Indeed, leaders on both sides of the war saw the propaganda value in the evolving technologies of journalism. They invited photographers and film makers to the war, even scheduling battles and executions so that the events could be recorded.

And there were plenty of photographers eager to cover the war. Heavy international interest in the revolution fueled a lucrative newspaper market for pictures of the action. Into this market stepped Agustín Victor Casasola, a former typographer and sports writer. Casasola and his brother Miguel founded one of the very first photographic agencies to take advantage of interest in the

Mexican Revolution. Some observers say that Agustín was also a skilled cameraman. But it's hard to say for sure because Agustín had a habit of buying the work of other photographers, scraping their name off and selling the photographs under his name. True to form, Agustín promptly sent his brother off to the warfront. Agustín himself spent most of the war in the Mexico City, safely away from the fighting, scratching his brother's name off of photos and selling them as his own.

That's more work than it sounds like. The modern day collection in Pachuca contains more than 760,000 prints and negatives, with over 30,000 images of the revolution by several hundred photographers. From his office in Mexico City, Agustín organized the Mexican and foreign photographers to cover the important events of the revolution. Aside from his brother, Agustín bought pictures from Jimmy Hare, Hugo Breheme and Manuel Ramos, among other. He even bought up whole newspaper archives as he did when El Imparcial, the first paper he worked for, went out of business.

The result of all this collecting is an incredible wealth of visual history about the Mexican Revolution. Casasola's peculiar style of collecting will provide research material for scholars for years to come, as they try to untangle the myths that Casasola and others built up around the collection as well as the historical facts behind the photographs. As researchers pursue this work, the photographs in the collection will continue to provide a rich testament to the men and women who fought and suffered in the Mexican Revolution.

Friedrich Katz is the son of Austrian Jews who sought refuge in Mexico at the start of WWII. His historical research brought new attention to the importance of northern Mexico and Pancho Villa in the Mexican Revolution. He is Professor Emeritus of Latin American History at the University of Chicago and the namesake of its Katz Center for Mexican Studies.

OTHER BOOKS YOU'LL ENJOY FROM CINCO PUNTOS PRESS

LAS SOLDADERAS
Women of the Mexican Revolution
by Elena Poniatowska

RINGSIDE SEAT TO A REVOLUTION
An Underground Cultural History of El Paso and Juarez: 1893-1923
by David Dorado Romo

PURO BORDER
Dispatches, Snapshots and Graffiti from the U.S./Mexico Border
edited by Luis Humberto Crosthwaite, Bobby Byrd & John William Byrd

DIRTY DEALING
Drug Smuggling on the Mexican Border and the Assassination of a Federal Judge: An American Parable
by Gary Cartwright

CONTRABANDO
Confessions of a Drug-Smuggling Texas Cowboy
by Don Henry Ford, Jr.

THE STORY OF COLORS / LA HISTORIA DE LOS COLORES
A Folktale from the Jungles of Chiapas
by Subcomandante Marcos
illustrated by Domi

THE SHADOW OF THE SHADOW
A Novel
by Paco Ignacio Taibo II

FRONTERA DREAMS
A Héctor Belascoarán Shayne Detective Novel
by Paco Ignacio Taibo II

VISIT US AT WWW.CINCOPUNTOS.COM